To:

......................................

From:

......................................

Other books in this series

Mother's Love
Love You, Dad
True Love
Friends Forever
The World Awaits
The Little Book of Thanks

amazing moms

Love *and* Lessons *From* *the* Animal Kingdom

Rachel Buchholz

NATIONAL GEOGRAPHIC

Washington, D.C.

Published by National Geographic Partners, LLC
1145 17th Street NW, Washington, DC 20036

ISBN: 978-1-4262-1667-1

Since 1888, the National Geographic Society has funded more than 14,000 research, exploration, and preservation projects around the world. National Geographic Partners distributes a portion of the funds it receives from your purchase to National Geographic Society to support programs including the conservation of animals and their habitats.

National Geographic Partners, LLC
1145 17th Street NW
Washington, DC 20036-4688 USA

Get closer to National Geographic explorers and photographers, and connect with our global community. Join us today at nationalgeographic.com/join

For rights or permissions inquiries, please contact National Geographic Books Subsidiary Rights: bookrights@natgeo.com

Interior design: Katie Olsen

Printed in Canada

22/FC/4

To all the mothers in my life:
Nana, Aunt Mary Ann, Kathi, Sheila,
and, of course, Mom!

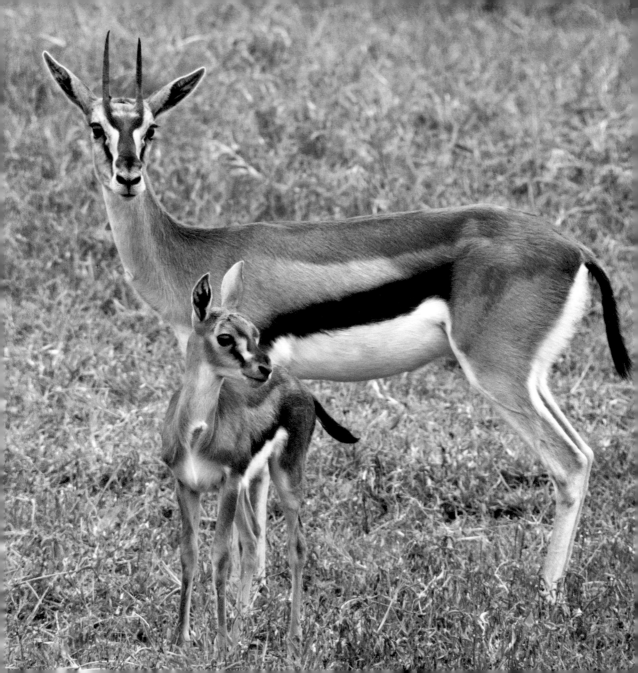

Introduction

When I was in kindergarten, I had a very old teacher who had some very old ideas about left-handedness. To her—and to many others of her time—being left-handed was a disability, a sign of stupidity. So anytime I pulled out a pencil, she'd yank it from my left hand and force it into my right. In my teacher's mind, she was trying to cure me. In my mother's mind, she was preying on me. Marching straight to the principal's office, my mother went on the attack to protect her southpaw daughter. It's not exactly a gazelle head butting a baboon to defend her fawn. But both human and animal moms come in all forms of amazing, whether they're helping out other mothers, being role models, or protecting their young … even when the baddies are elderly kindergarten teachers.

Thomson's gazelle mothers are known to defend their young against predators such as jackals and baboons.

No language can express
the power, and beauty,
and heroism, and majesty
of **a mother's love.**

EDWIN HUBBELL CHAPIN

No animal has a more distinctive coat than the zebra.
Each zebra's stripes are as unique as fingerprints.

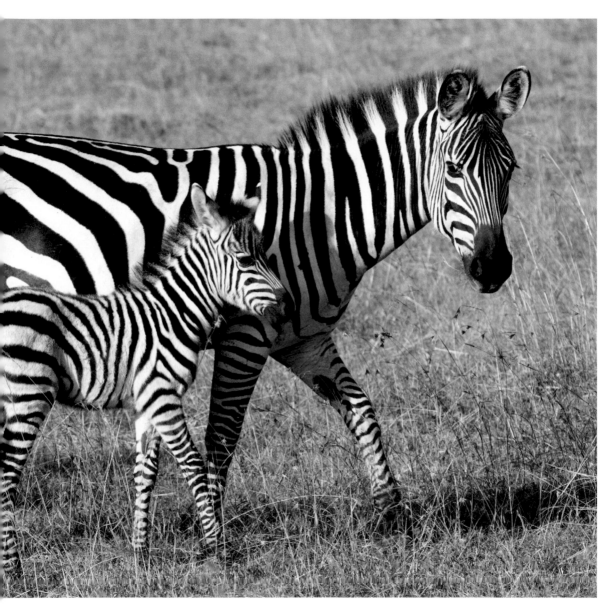

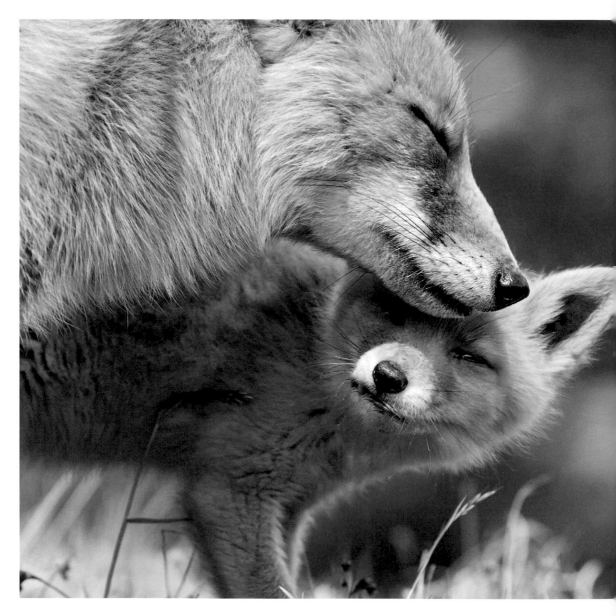

Showing gratitude
is one of the **simplest
yet most powerful**
things humans can do
for each other.

RANDY PAUSCH

*Red fox pups are born with brown or gray coats. A new red coat usually
grows in by the end of their first month, but some red foxes are golden,
reddish brown, silver, or even black.*

Jumping In

It might seem strange to care about a tadpole, but strawberry poison dart frog moms certainly care about theirs. After her eggs hatch, the mother carries up to five tadpoles on her back to bromeliad plants in Central American rain forests. She deposits each tadpole into the water-filled center of its own bromeliad, where the leaves have grown into a rosette, similar to the shape of the top of a pineapple. Every day for nearly two months, she returns to the plants to care for her babies and lays up to five unfertilized eggs for each tadpole to chow down on. This frog mom doesn't really care that her babies don't look like her—yet. She's still going to care for them no matter what.

Mom has a good reason for placing her tadpoles in separate plants:
Tadpoles are cannibalistic. Talk about sibling rivalry!

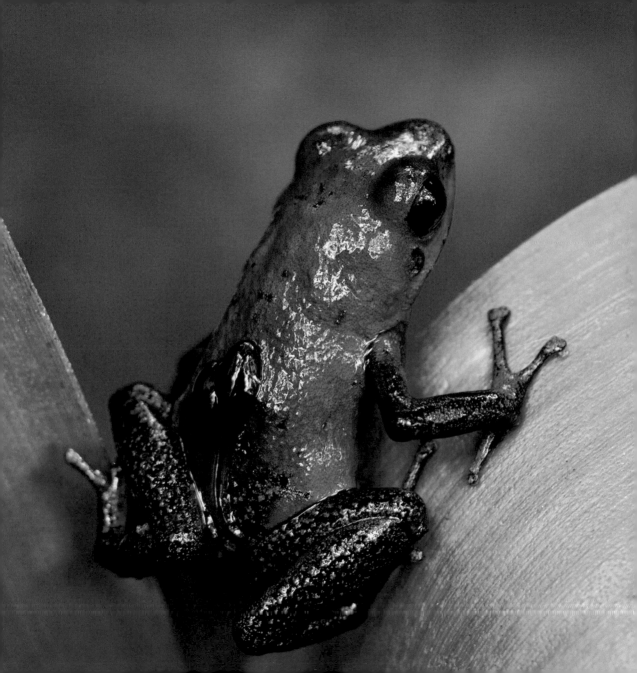

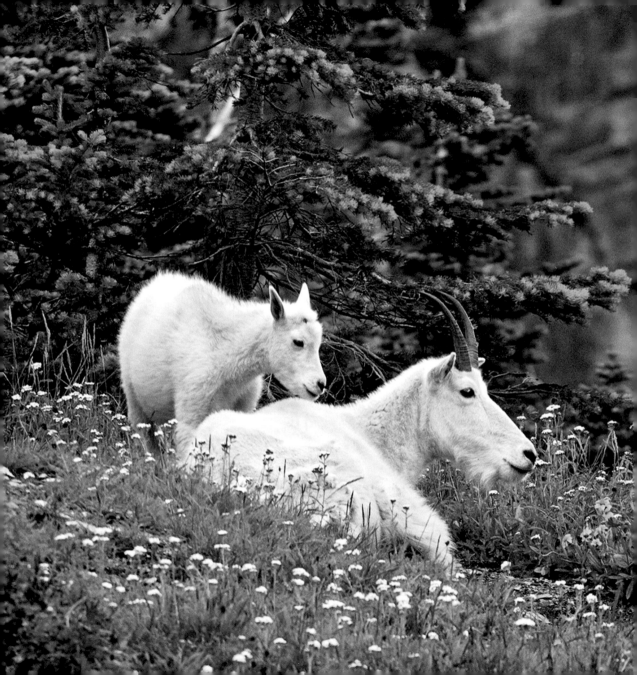

Let us love, since that is all
our hearts were made for.

ST. THÉRÈSE OF LISIEUX

Nannies and kids, female and young mountain goats, respectively,
spend most of their time in a herd with as many as 20 other mountain goats.

Twenty-four seven …
Once you sign on to be
a mother, that's the **only
shift they offer.**

JODI PICOULT

*Native to the African island of Madagascar, ring-tailed lemurs
are closely protected endangered animals.*

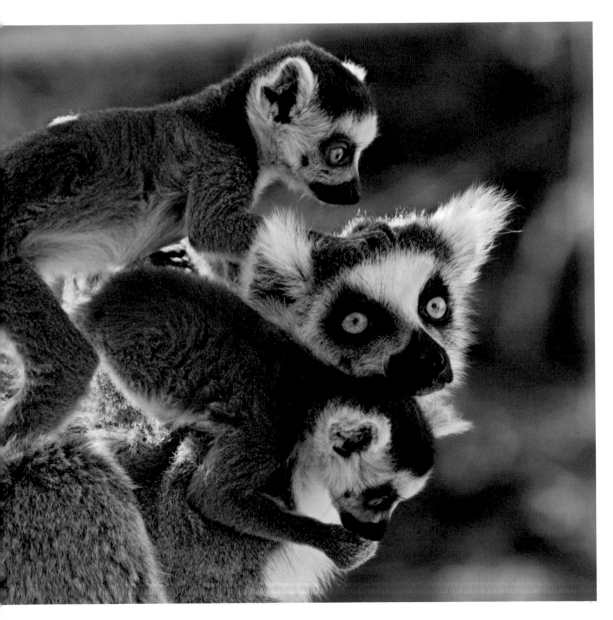

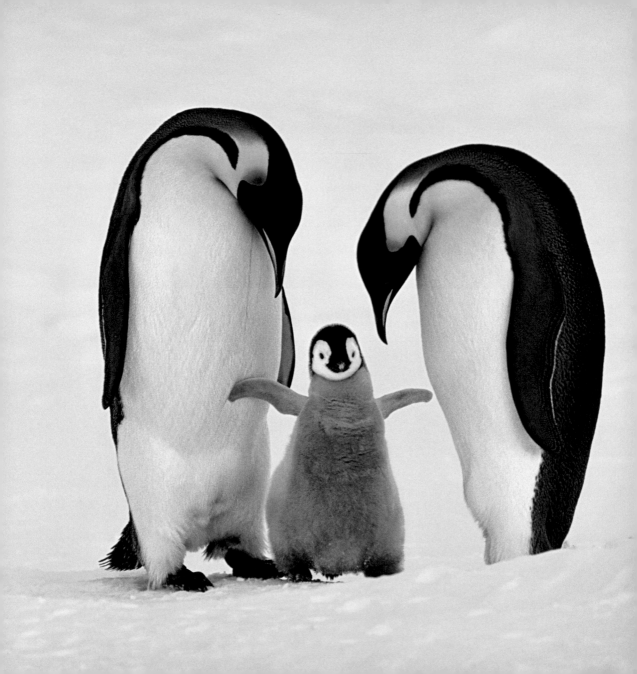

Out to Sea

It's freezing. Actually, it dips below freezing, as the mercury plummets to minus 75°F (-59°C) in Antarctica. A female emperor penguin has just given her new egg to her mate. For the next two months, he's in charge. He'll balance the egg on his feet, keeping it warm inside his feathered brood pouch. The female penguin will leave. Least attentive mom ever? Nah. She'll travel up to 50 miles away to the open ocean to dive for fish, squid, and krill, eating as much as she can. When she returns to her newly hatched chick, she'll regurgitate the food into its mouth. Why does the emperor penguin mom spend all this time away from her family? Amazingly, it's all to raise a happy, healthy chick.

Once the female emperor returns, she and her mate will share the responsibility of keeping their baby safe from the harsh Antarctic temperatures.

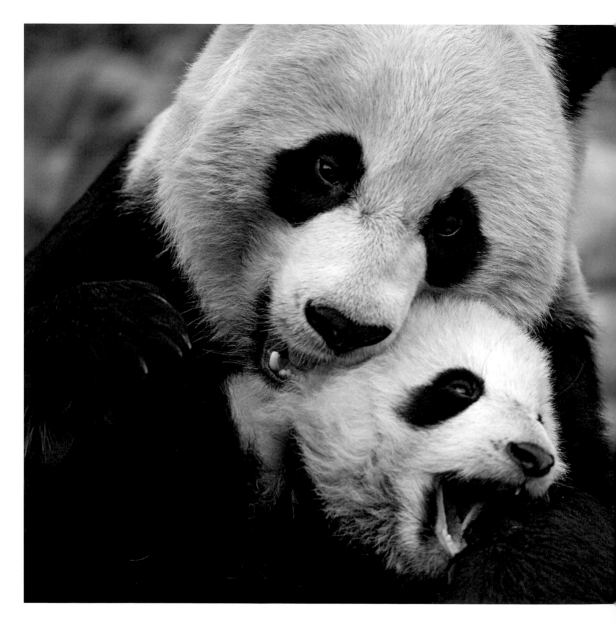

It's the **simplest things in life** that are the most extraordinary; only wise men are able to understand them.

PAULO COELHO

At birth, newborn panda cubs are 1/900 the size of their mother, making them one of the smallest newborns relative to their mother.

Mothers **hold their children's hands** for just a little while and their hearts forever.

IRISH PROVERB

Donkeys are herd animals and can even hear the call of another donkey up to 60 miles away.

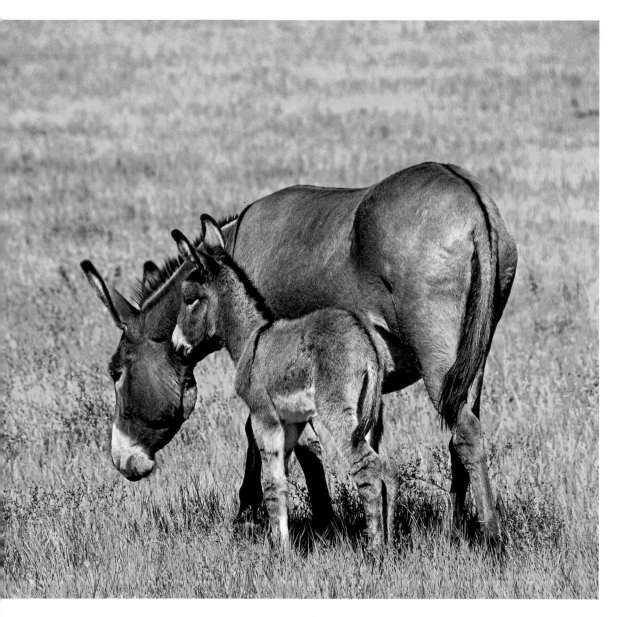

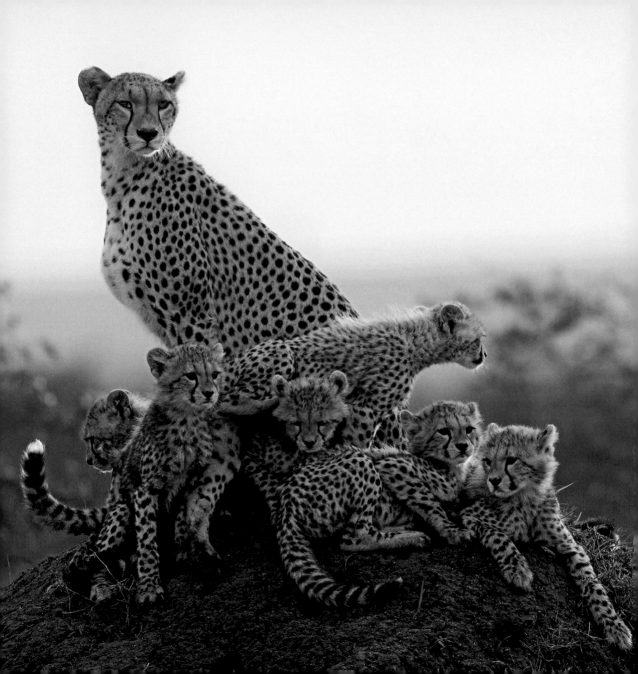

Spot Training

As the world's fastest land mammal, cheetahs are often considered to be the perfect predator. But they certainly aren't born ready for that role. In fact, newborn cheetahs have no survival instincts, which leaves them pretty helpless. Luckily, Mom is on the case. It's up to her to teach them the skills they need in order to grow up strong, fast, and successful. For two years, they'll watch her closely. They'll learn how to use their spotted coats to blend into the African grasslands. They'll observe how to burst onto their prey and bring it down quickly. When it comes to surviving and thriving, their mother is the best teacher they could have.

Cheetah moms will encourage their cubs to practice their hunting skills by play fighting.

What is a mom but the
sunshine of our days
and the north star
of our nights.

ROBERT BRAULT

Female dogs begin caring for their puppies immediately after they are born. They will lick clean their sightless, hearingless puppies, helping them to breathe and encouraging them to nurse.

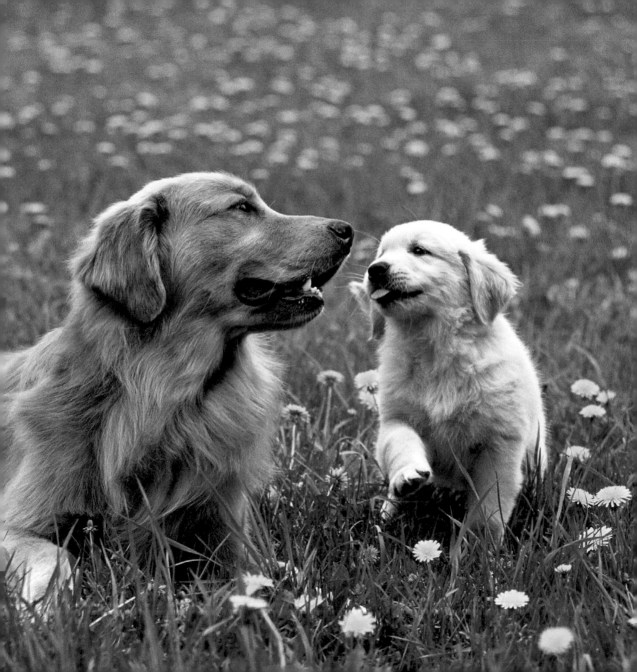

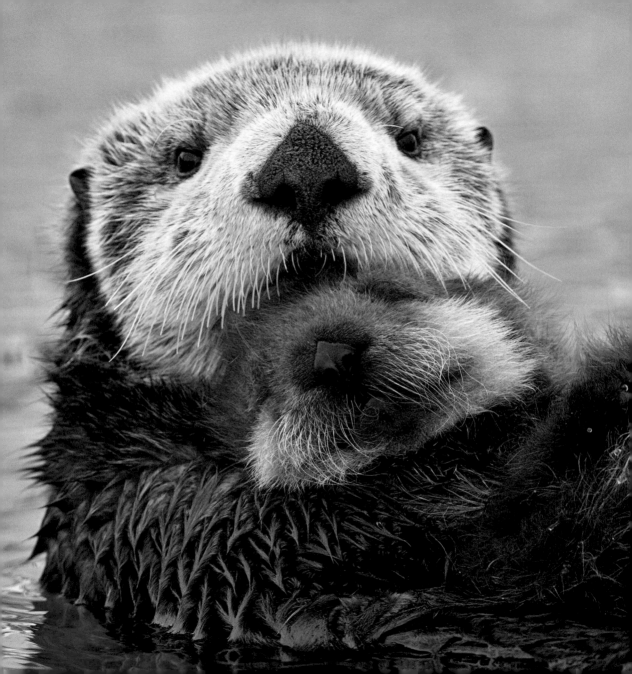

Every day **is a journey,** and the journey itself is home.

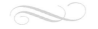

MATSUO BASHO

Sea otters are the only otters to give birth in the water. Mothers nurture their young while floating on their backs. They hold infants on their chests to nurse them and quickly teach them to swim and hunt.

No Empty Nests

The bond between a female orangutan and her young is like no other in the animal kingdom. Living in the rain forests of Borneo and Sumatra, the female only has one offspring roughly every eight years, and mom and baby stay together for six or seven years. (Bornean orangutans may become independent a little earlier.) During that time the young orangutan learns to navigate the forest and picks up tips and tricks from its mom. They even have their own bedtime ritual. Climbing into a fork of a tall tree, the mom will bend branches to create a mattress of leaves and twigs just big enough for the two of them. Sometimes, if it's raining, she'll add a roof with more branches to keep her baby dry. It's a cozy place to fall asleep, just mom and baby.

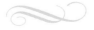

Female orangutans will leave the nest to start their own families
but have been known to come back to Mom for a visit.

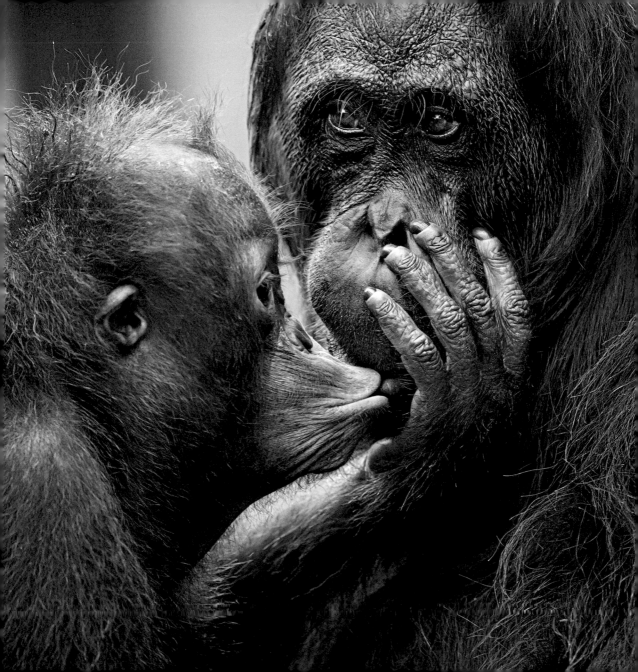

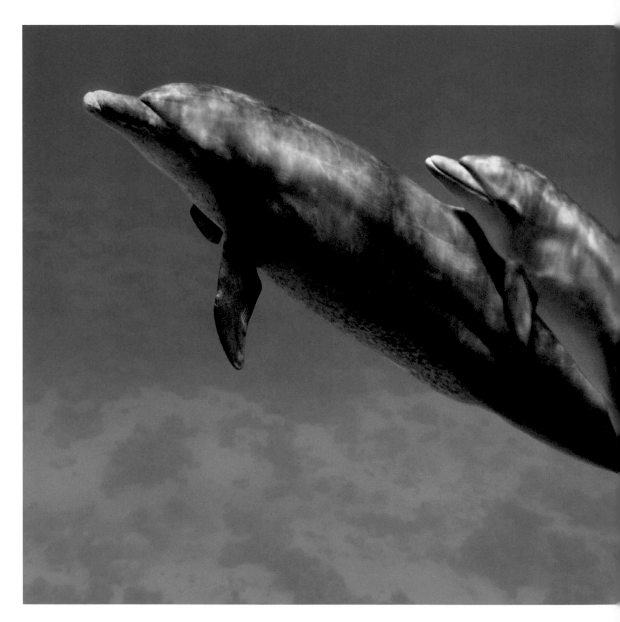

It is only with the heart
that one can see rightly;
**what is essential
is invisible** to the eye.

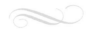

ANTOINE DE SAINT–EXUPÉRY

*Bottlenose dolphins travel in social groups and communicate
with one another by a complex system of squeaks and whistles.*

All that I am, or **hope to be,** I owe to my angel mother.

ABRAHAM LINCOLN

Female tigers give birth to litters of two to six cubs, which they raise mostly on their own. Cubs cannot hunt until they are 18 months old and remain with their mothers for two to three years, when they disperse to find their own territory.

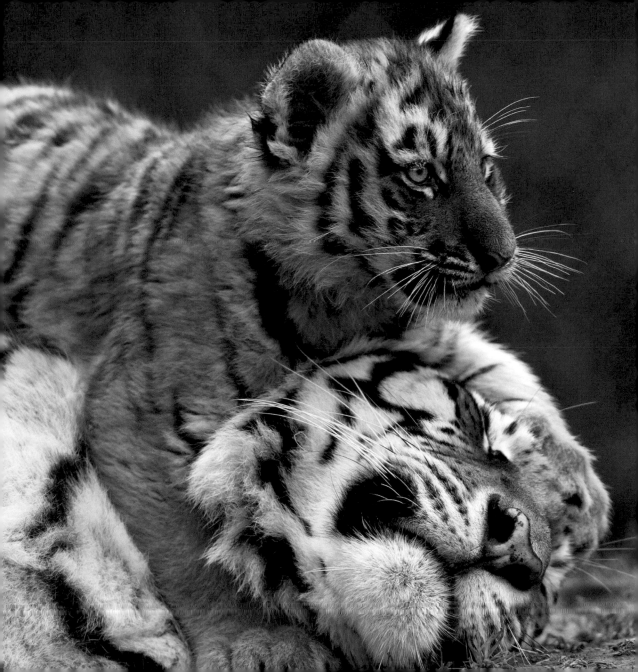

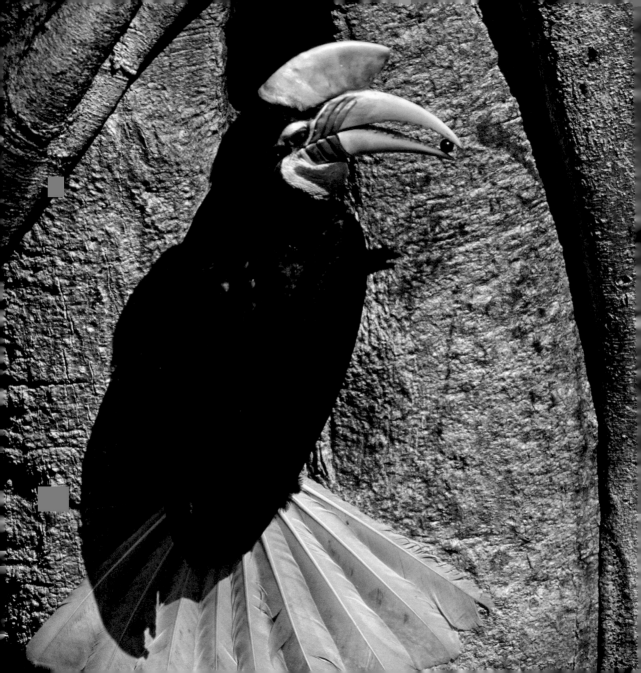

Whatever It Takes

Most moms *say* they will do anything for their kids, but red-knobbed hornbills know that actions speak louder than chirps. For these Indonesian birds, it's not enough to build a nest—they scope out large trees and build their nests inside holes in the trees. But Mom doesn't stop there. To protect her newly laid eggs from hungry monitor lizards, she'll seal herself inside the hole by patching it with her own poop! She'll stay there and sit protectively in the nest for two months, entirely dependent on her mate to bring her food through a narrow slit in the hole.

Dedication like this is definitely for the birds.

Hornbill hatchlings stay confined to the nest for about four months. Mom helps work their wing muscles by encouraging them to fly after her as she forages for figs.

Live so that when your
children think of fairness,
caring, and integrity,
they **think of you**.

H. JACKSON BROWN, JR.

*Young harp seals are born on the ice, and mothers identify
their own offspring from the multitudes by their smell.*

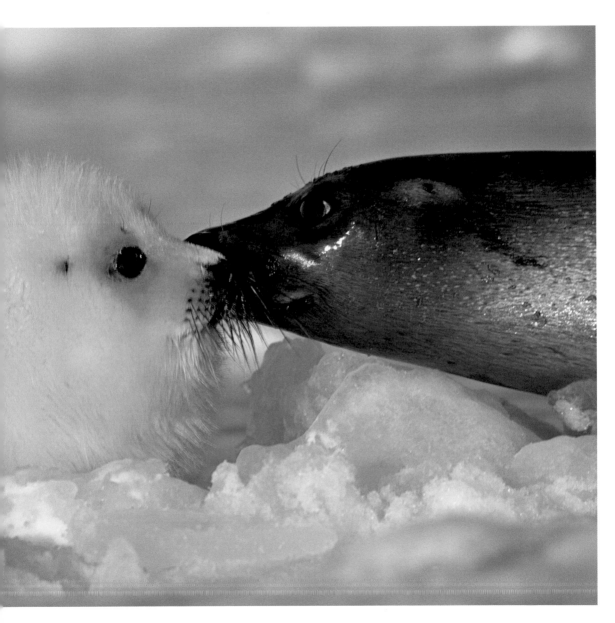

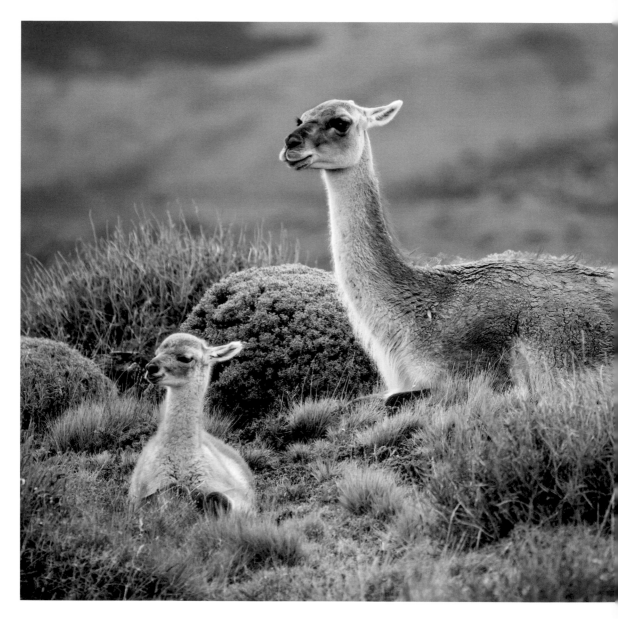

It's not only children who grow. Parents do too. As much as we watch to see what our children do with thcir livcs, **thcy arc watching us** to see what we do with ours. I can't tell my children to reach for the sun. All I can do is reach for it myself.

JOYCE MAYNARD

Young guanacos are fast learners. Just five minutes after birth, they are standing and following their mothers around the mountains and plains of South America.

All in the Family

Every child needs a role model to look up to and learn from. Luckily for baby African elephants, or calves, they're surrounded by them! Related females help raise all the young in a herd and set examples through their behavior. When a mom makes a tool, such as a flyswatter out of a leafy branch, a young elephant will make one too. If a female uses her trunk to forage for food, such as berries, leaves, and grasses, the baby will do the same to learn what's edible. Young elephants even learn parenting skills by watching a mom—when she gently wraps her trunk around her newborn calf and lifts it to its feet, for example. In the elephant world, there's no shortage of strong female role models.

Mother elephants use their trunks to help their babies
move around obstacles and pull them out of holes.

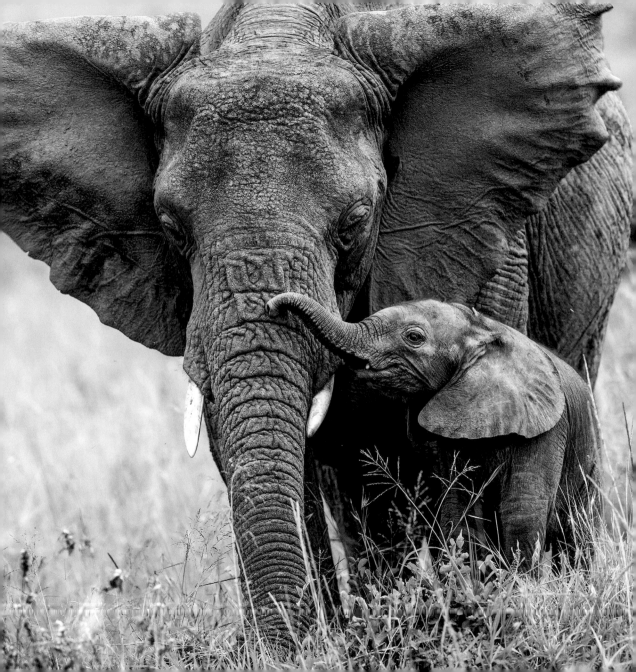

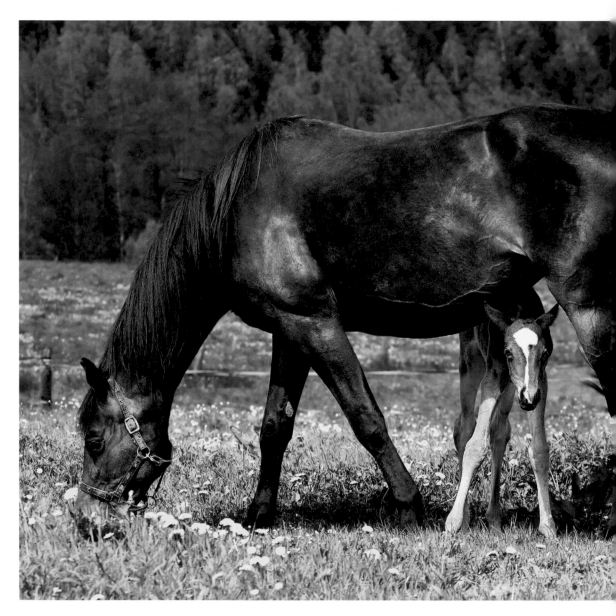

The **best thing** she was,
was her children.

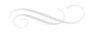

TONI MORRISON

A young horse, or foal, relies on its legs as much as its mother. Within minutes
of being born, the foal can stand, allowing it to nurse and gain strength.

The attitude you have
as a parent is what your kids
**will learn from more
than what you tell them.**
They remember what
you try to teach them.
They remember what you are.

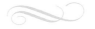

JIM HENSON

*Polar bears roam the Arctic ice sheets and swim in that region's coastal waters.
Young polar bear cubs live with their mothers for some 28 months
to learn the survival skills of the far north.*

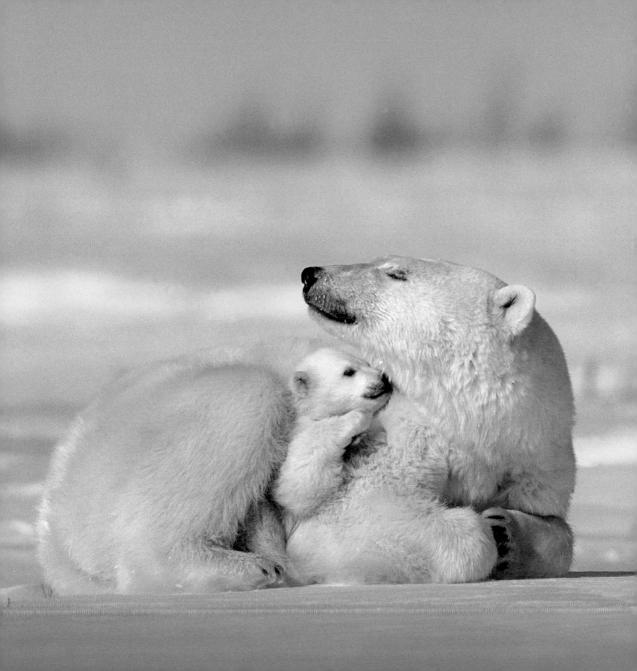

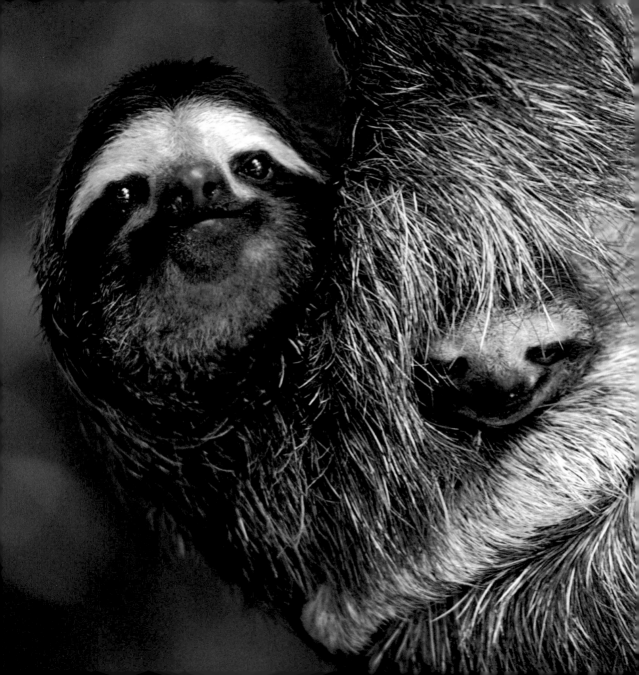

Hanging Out

Sloth babies are definitely clingy—but that's a good thing! For roughly the first nine months of its life, a baby sloth holds on to its mom as she hangs from tree branches in Central and South America. The young sloth is completely dependent on its mother for food and protection, as it isn't even strong enough to grip trees on its own. Luckily, the baby doesn't need *too* much strength to hang on to Mom—she sleeps up to 20 hours a day and doesn't move much until she ... *very slowly* ... makes her way down once a week for a bathroom break. This break makes mom and baby vulnerable to predators such as jaguars and hawks, but that's when Mom goes from sluggish to slugger: biting, clawing, and hissing to defend herself and her young. Going from laid-back to prizefighter is this mom's secret superpower.

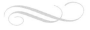

A sloth often gives birth hanging upside down in a tree. Other sloths will clean the baby and help make sure it doesn't tumble to the ground.

A female mallard duck's brood averages about nine ducklings. She leads them to the water and protects them for the first few months, but they are self-sufficient and able to swim, waddle, and feed from birth.

A wise woman once said to me
that there are **only two
lasting bequests** we can
hope to give our children.
One of these she said is roots,
the other, wings.

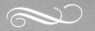

HODDING CARTER

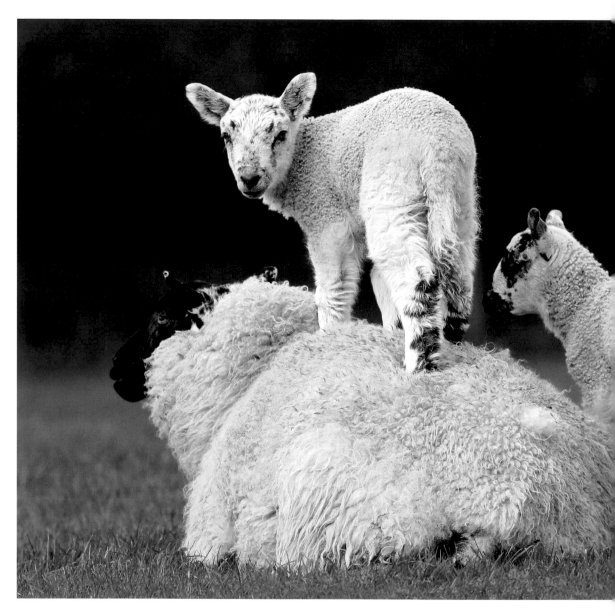

It will be a little messy,
but **embrace the mess.** It will
be complicated, but rejoice
in the complications.

NORA EPHRON

Female sheep, or ewes, are very attentive mothers.
They can distinguish their lamb's call from others.

Don't Mess With Mom

Most people wouldn't consider giving a crocodile a Mother of the Year award. Yet despite their fierce reputations—a 20-foot Nile croc will take down everything from a zebra to a human—these reptiles are actually devoted mothers. Most reptiles lay their eggs and then disappear forever. But a crocodile mom keeps a close watch on her nest after she's buried her eggs, guarding it for three months from potential predators. Her babies will make high-pitched squeals when they're about to hatch, and Mom will quickly dig up the eggs. Once hatched, the babies ride in Mom's mouth as she carries them to the water where they'll live under her protection for about two years. Seems like when it comes to crocodiles, an outer toughness hides an inner gentleness.

A crocodile mom will roll her eggs in her mouth to help them hatch.

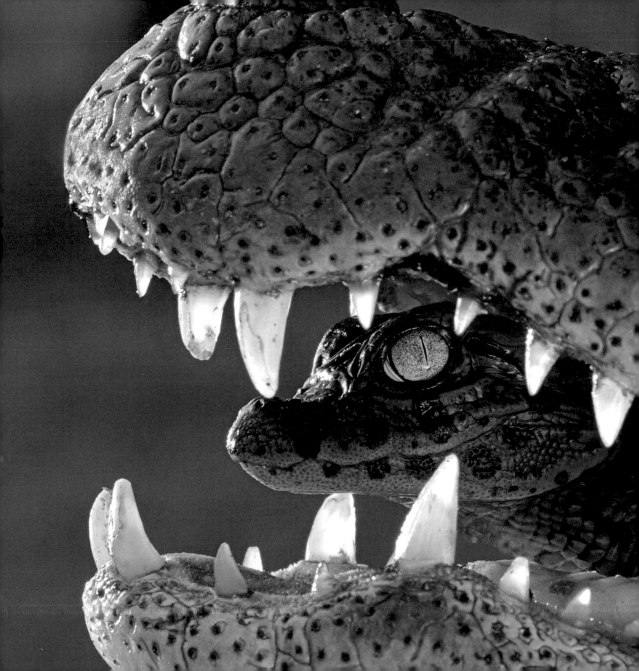

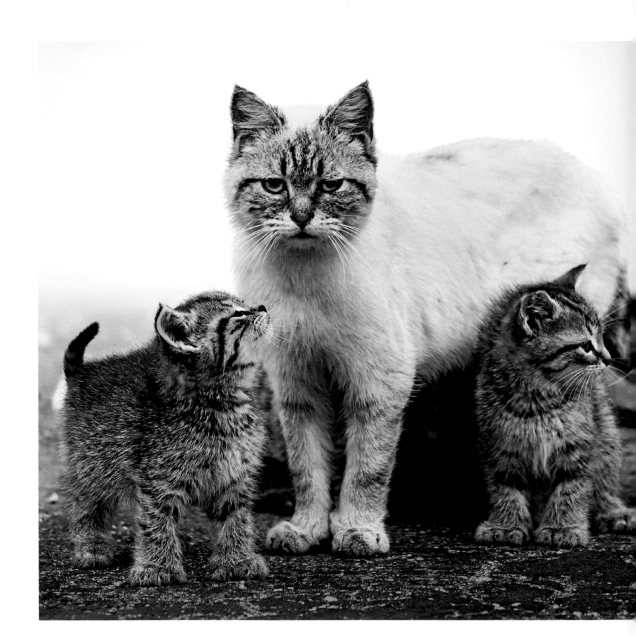

Do anything,
but let it **produce joy.**

HENRY MILLER

Kittens are extremely dependent on their mothers after birth.
For the first few weeks, their mother needs to keep them warm, help them
go to the bathroom, and feed them nutrient-dense milk.

But kids don't stay
with you if you do it right.
It's the one job where,
the better you are, the more
surely you won't be needed
in the long run.

BARBARA KINGSOLVER

*Hippo calves weigh nearly 100 pounds (45 kg) at birth and
can suckle on land or underwater by closing their ears and nostrils.*

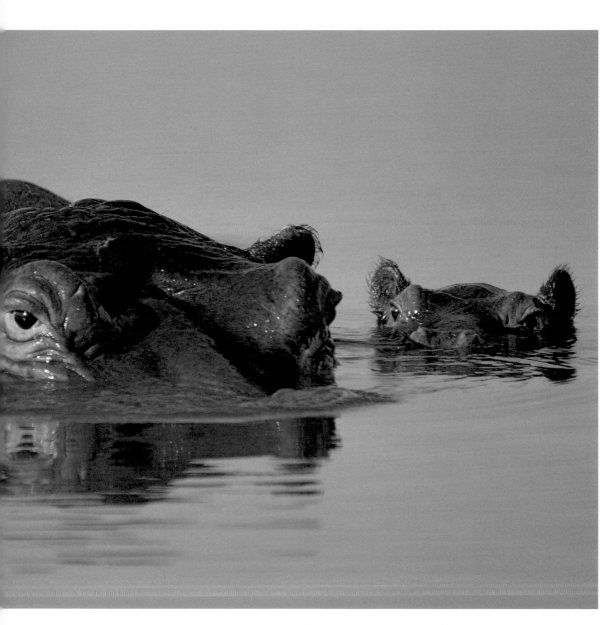

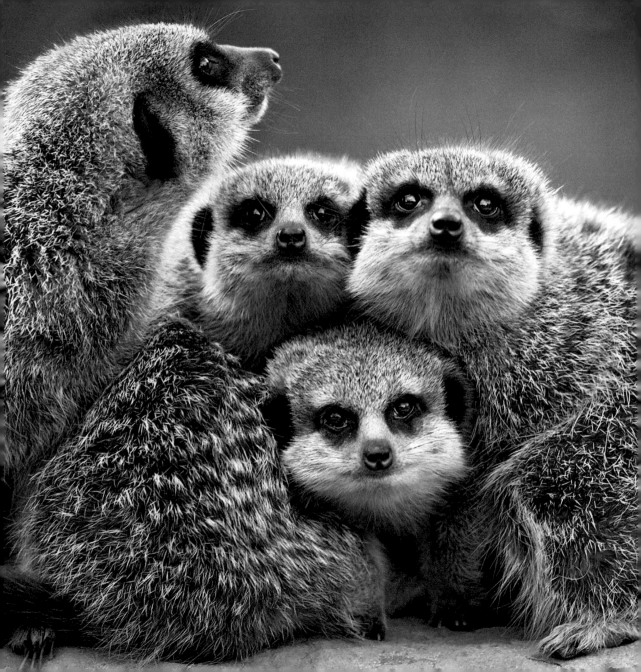

Mob Moms

In a meerkat family, everyone's a mom! About 40 meerkats live in groups called mobs, and each meerkat has a job. A lot of times the job is to take care of baby meerkats, or pups. While the rest of the family is out foraging the African savanna for beetles, caterpillars, and spiders, the babysitters stay in the burrow to protect the young meerkats from predators such as eagles and hawks. They'll even nurse other mothers' babies and sometimes cut the stingers off of scorpions so the young meerkats can have a snack. Meerkat moms know it's okay to call for help—especially when that help keeps her babies safe.

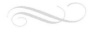

A meerkat mom can nurse her baby while standing on her hind legs often while on the lookout for predators.

Love is **something more** stern and splendid than mere kindness.

C. S. LEWIS

Lion prides are family units that may include up to three males, a dozen or so females, and their young. All of a pride's lionesses are related, and female cubs typically stay with the group as they age, but young males eventually leave.

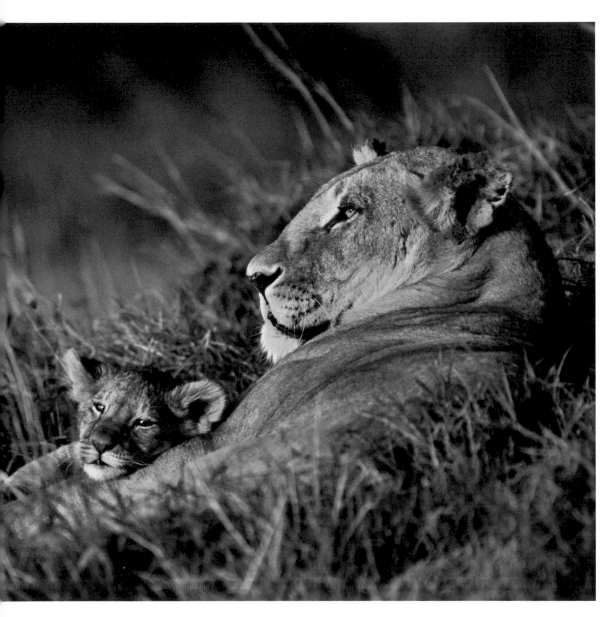

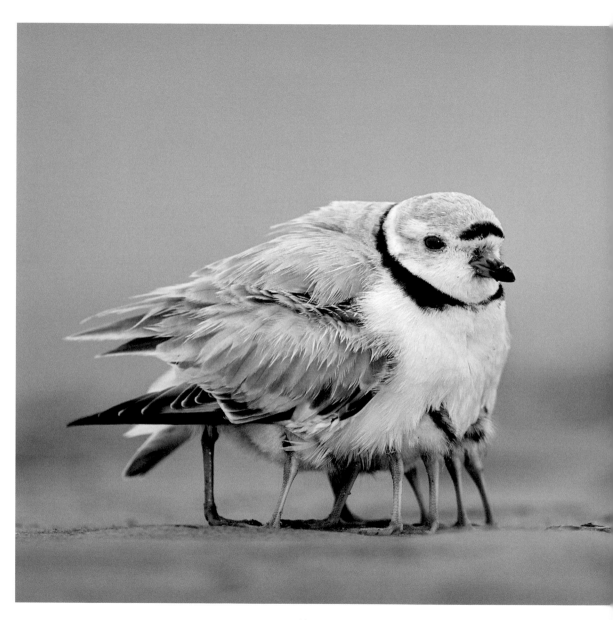

Remember at any
given moment there are
a thousand things
you can love.

DAVID LEVITHAN

Piping plovers will often feign an injured wing to distract
approaching predators in order to keep their chicks safe.

Whale Tale

Humpback whales are solitary creatures. Unlike dolphins or orcas who travel in pods, humpbacks prefer to keep to themselves and swim solo. Except, that is, moms and babies, who share an incredible bond. After bringing the baby, or calf, to the water's surface for its first breath, the humpback whale mother stays with her calf for a year, never straying more than a body length away. She'll patiently watch the baby unsuccessfully attempt to breach or flap its tail, and then she'll demonstrate proper humpback technique. Moms and babies will also touch each other's flippers in what many believe is a gesture of affection. The humpback mother's constant support means that one day her baby will be able to dive headfirst into life on its own.

A humpback mom's yogurt-like milk is almost 50 percent fat.
No wonder babies grow up to 30 feet (9 m) during their first year.

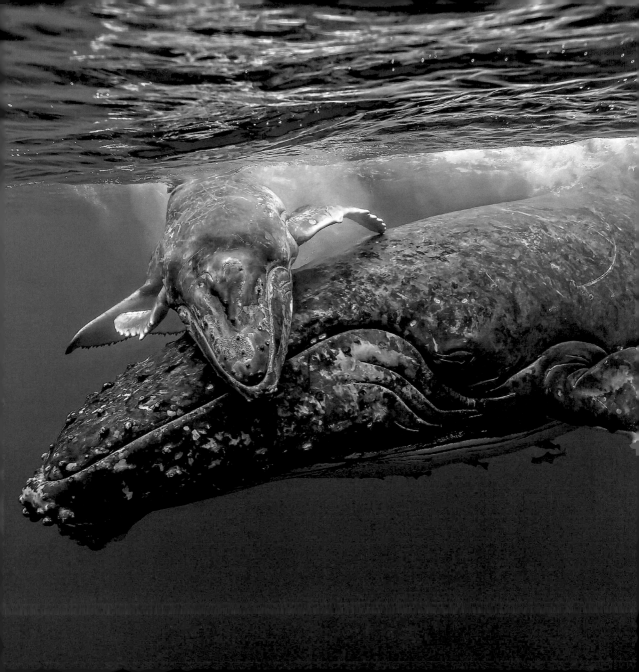

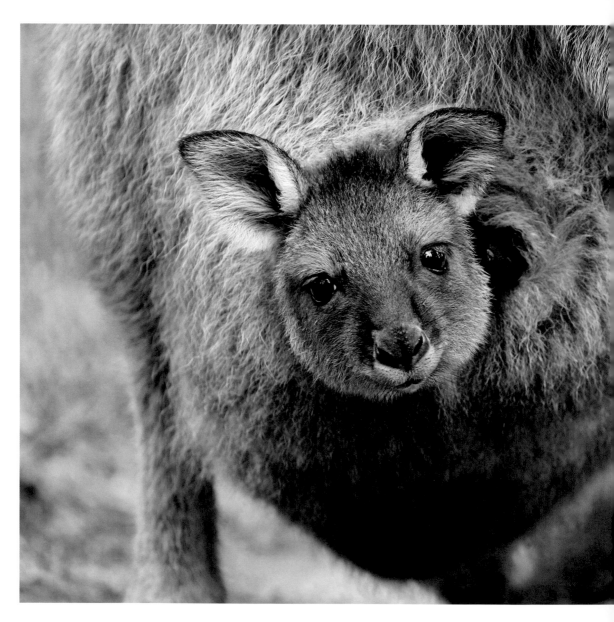

He who takes
the child by the hand
takes the mother
by the heart.

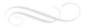

DANISH PROVERB

Kangaroo joeys spend the first two months of their lives in their mother's
pouch, but they use it to escape potential danger for up to eight months.

I am beginning to learn that it is the **sweet, simple things of life** which are the real ones after all.

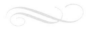

LAURA INGALLS WILDER

Brown bear cubs are born during winter hibernation. They nurse on their mother's milk until spring and stay with her for some two and a half years.

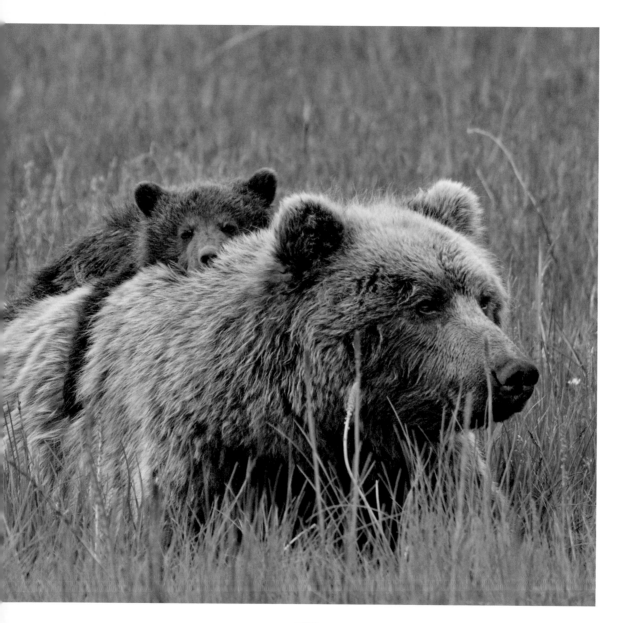

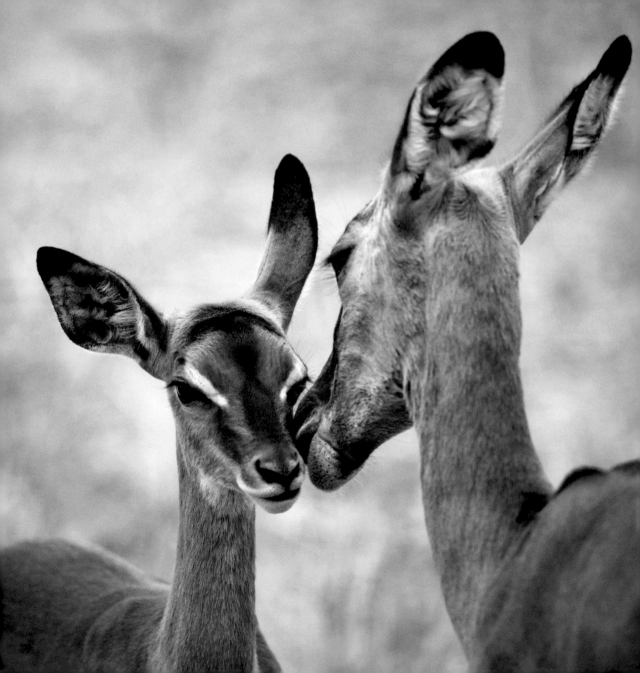

Stealth Mom-er

Gazelle moms are sneaky. They know that predators such as cheetahs are watching them closely, hoping the moms will walk too close or look too often toward the plains grasses where they've hidden their young. The babies' mottled brown-and-white coloration helps them blend in with the tall African grassland. But that's not enough. The mom must behave as if her babies don't exist, taking care not to constantly look in their direction or wander too close to their hiding spot. That way, the predators can't figure out where the babies are and will move on to easier prey. Sometimes a little creativity in raising babies goes a long way.

Gazelles live in herds, which baby gazelles join weeks after being born; until then, they are hidden and periodically nursed by their mothers.

Burrowing owl chicks leave the nest not long after birth. They can hunt for insects and take flight around six weeks after hatching.

The only way we will survive **is by being kind.** The only way we can get by in this world is through the help we receive from others. No one can do it alone.

AMY POEHLER

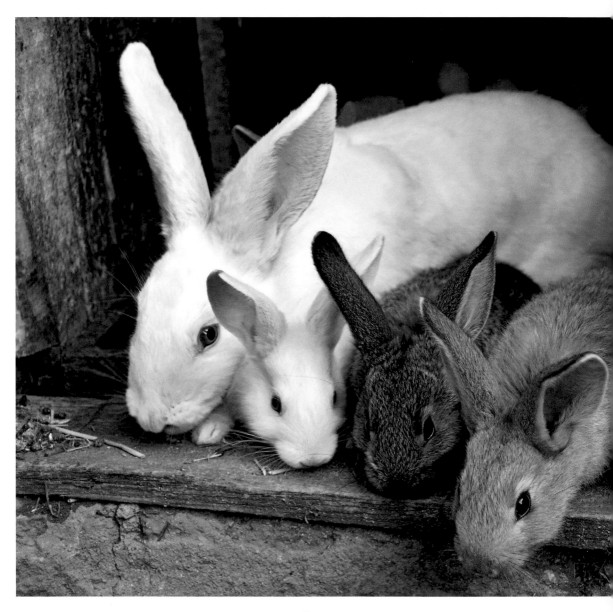

Try to be **a rainbow**
in someone's cloud.

MAYA ANGELOU

Baby rabbits are actually called kittens or kits
The term "bunny" can be used for rabbits young or old.

Pocket Protector

A koala joey peeks out of his mother's protective pouch. In the six months since he was born, the joey has been safe, snuggled, and growing in the pouch. He has grown from a blind, furless, earless jelly bean–size creature to the cute fur ball he is today. His mom will carry him in her pouch for another six months, after which time she'll continue to tote him around close to her, on her belly or her back, as the two move from tree to tree in the Australian forest in search of eucalyptus leaves to eat. By keeping the joey near her, the koala mom protects her baby, making him feel safe and secure until he's ready to branch out on his own.

Koalas may rest in the forks or nooks of a eucalyptus tree
for upwards of 18 hours a day.

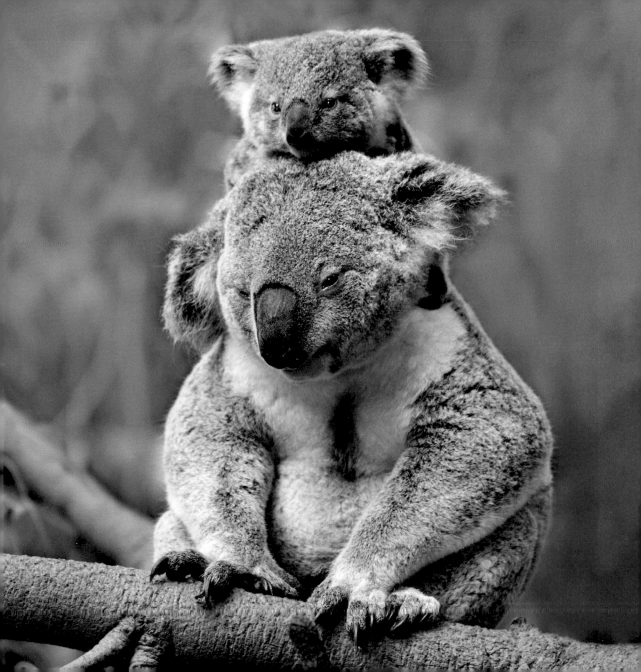

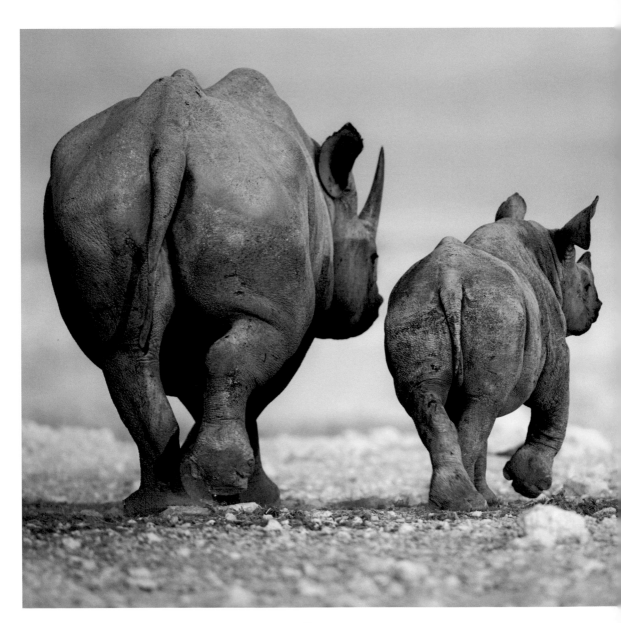

When sleeping women wake, **mountains move.**

CHINESE PROVERB

Normally solitary creatures, female black rhinoceroses stay with their calves until they are about three years old.

Those who **love deeply**
cannot age.

ARTHUR WING PINERO

Besides humans, macaques are the most widespread primate on Earth.

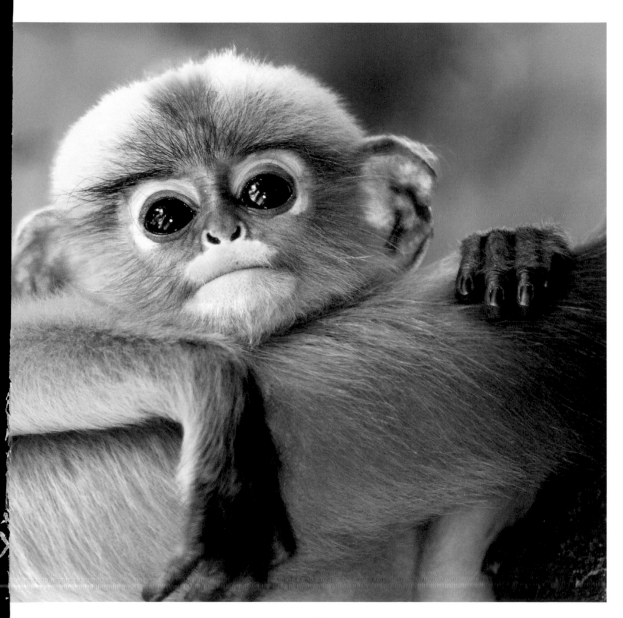

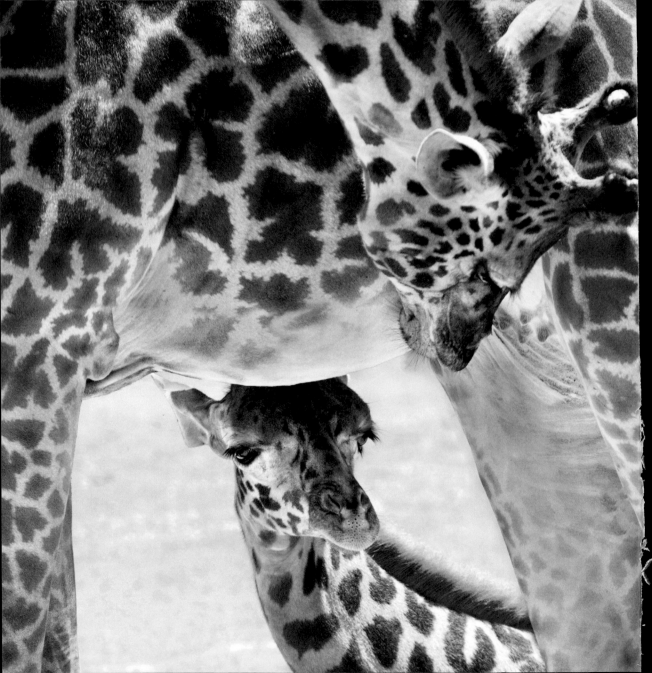

Safety in Numbers

The female giraffe looks alert. Her head held high, she scans the African savanna for her herd's feared predator—the lion. She's not in much danger, but the calves she's looking after in the nursery, while their moms eat and socialize, are easy prey. Luckily, the other moms are on the alert for a snort or grunt from the babysitter if she spots danger. This will trigger the females to rush back to defend their babies with swift kicks. Giraffe moms share in parenting duties and often give birth around the same time as other females in the herd. This decreases the chance of a vulnerable calf and mom falling prey to a lion pride. Instead, the females support each other and each other's babies, helping the entire herd stand tall.

Giraffes give birth standing up; their calves fall more than five feet (1.5 m) to the ground but are able to run with their moms within a day.

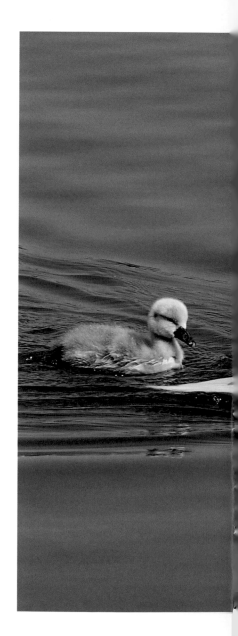

Mama exhorted her children
at every opportunity
to **"jump at de sun."**
We might not land on
the sun, but at least we
would get off the ground.

ZORA NEALE HURSTON

Generally known for her feisty temperament, a mother swan will
aggressively defend her babies from any perceived threat.

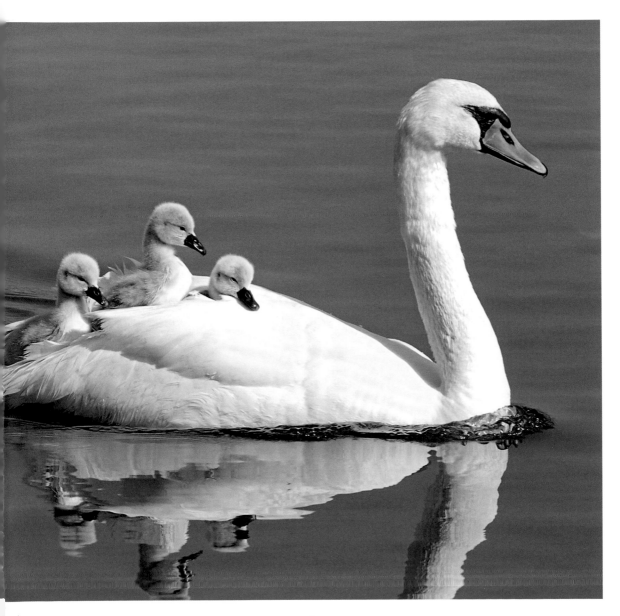

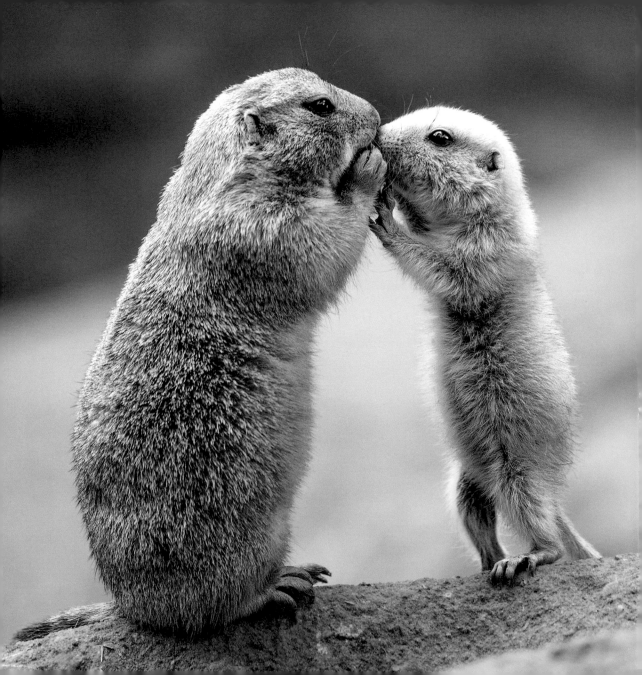

This was love:
a string of coincidences
that gathered significance
and **became miracles.**

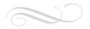

CHIMAMANDA NGOZI ADICHIE

Family groups of prairie dogs greet each other with a prairie dog kiss or nuzzle.

Photo Credits

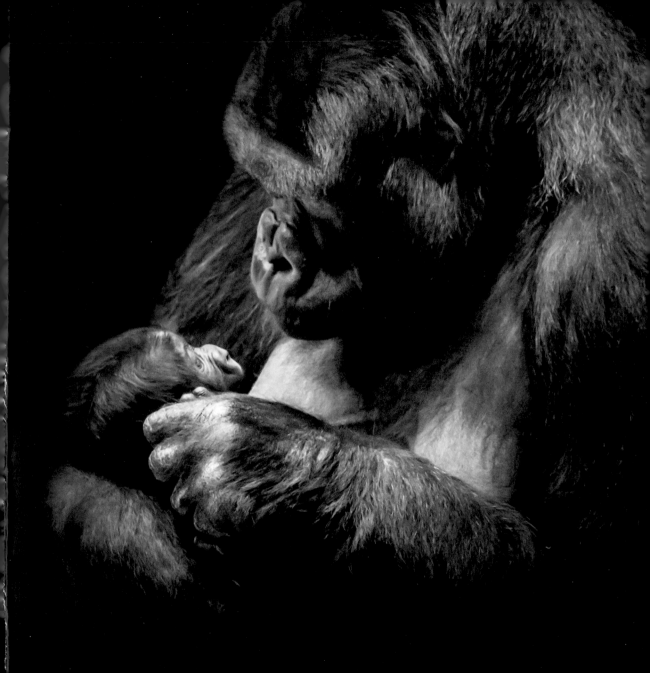

Enjoy More Stories About Life and Love From the Animal Kingdom

Warm, witty, and sure to bring an instant smile, these endearing little books are the perfect way to show someone you care.